L'AMOUR FOU

issue #3

Ra Press
100 Kennedy
 Drive 53
South Burlington
VT 05403

ARTISTIC DIRECTOR
Luis Lazaro Tijerina

LITERARY EDITORS

Dave Donohue,
Charles Watts,
Christopher Ricker

SURREALIST NOTE: ORIGINS

Christopher Ricker

I first met Luis Lazaro Tijerina during my years as a fledgling poet. The older writer bought me a coffee and shared his raspberry crumpet within the small space of a warm café in Burlington, Vermont. The two of us found ourselves in the Café in order to escape the onslaught of a northern winter storm. The discussion revolved around the direction of Western Literature.

During this experience in the August First Café, in my perspective, we gave birth to the concept of what is known today as the L'AMOUR FOU Magazine!

Surrealism: Opening the pages of this journal is similar to Pandora opening that large jar — what discharges may not be defined as dark, surreal, or even revolutionary. But still what is evil? What is surreal? What is ancient? What is the vehicle of revolution?

Did Rimbaud know? Did Aragon?

When André Breton said, "All my life, my heart has yearned for a thing I cannot name," was he not talking about art without borders?

I challenge you the writer and you the reader to step outside of yourself — break the barriers and strictures of literature, social constructs, your own self-imposed-consciousness, and, instead, feel art as it is and how it should be felt.

I welcome you all to L'AMOUR FOU, Issue #3.

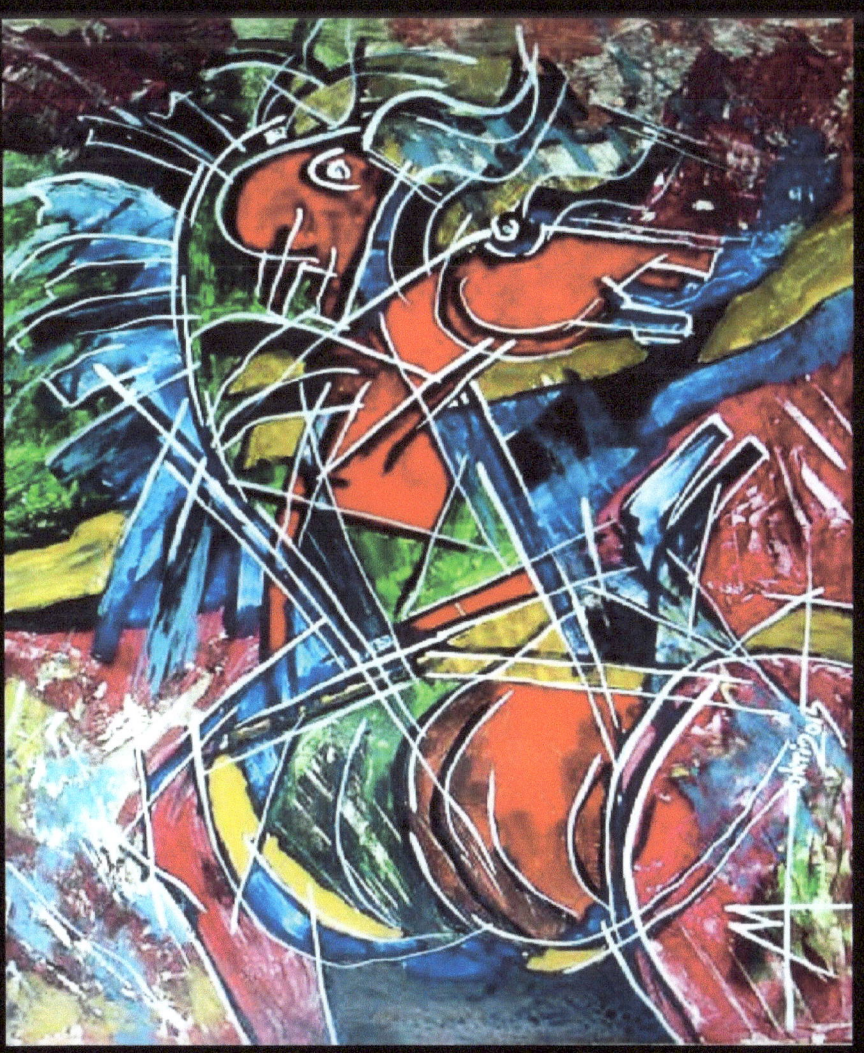

RED HORSES

Muktiram Maiti

excerpts from **MEMOIR OF PARIS**
Luis Lázaro Tijerina

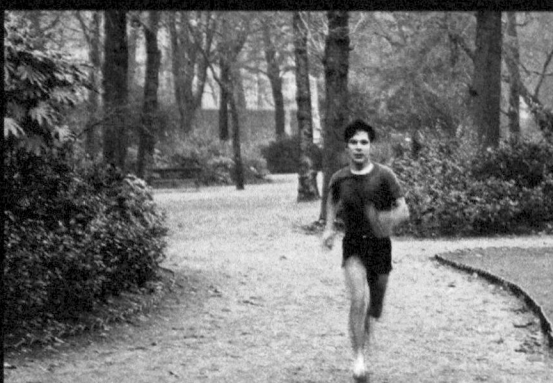

It was in those first days of my sojourn in Paris that I ran in the Luxembourg Gardens. Within a few days, I became more courageous and began to run towards the Musée De l' Armée. Eventually, I found myself running along the Seine. While running, I would observe the stone quays with the sunlight hitting them and I thought of Cartier Bresson's photography - a thought that always brought a tight smile to my face. It was Bresson who represented the best of Paris for me in relationship to sunlight and shadow and all the various elements of light that comprise Paris.

The surrealist movements could be seen on the streets and on both the old and more modern monuments.

I ran almost mesmerized through the streets of Paris. I ran for what seemed hours, sometimes thinking of the great and tragic character "Marcello" in the novel *The Conformist*. I thought about how that literary character created by Alberto Moravia had taught me how we destroy one other in so many ways; how deceit is present in every human soul and how that deceit rises to the surface during periods of great political stress and reaction. During those times, we do not know who we are nor even do we know who are our lovers, wives or spouses.

All this I thought about as I ran with a sure gait, my form being even and in conformity with all that was around me in Paris. I was young and I believed that I could win every race.

excerpts from **MEMOIR OF PARIS**

Luis Lázaro Tijerina

I ran from the American Hotel onto Rue Brea, a side street, then down to Rue Notre Dame, an avenue parallel to Montparnasse. After running down the paved streets in the cool night air, I jogged up to the part of Montparnasse Boulevard which leads directly to Boulevard Des Invalides. This Parisian boulevard spans out in the direction of the Eglise due Dime where Napoleon lay in his dark, red sarcophagus. The Elgise du Dôme glowed with a lighting that displayed the gray, yellow, and brown stone façade of the building. Le Dôme's lead sheeting gleamed under the Parisian night.

As I ran in front of Eglise du Dome, the autos sped rapidly though the intersections. I kept calm and continued running at a fast pace. I turned off the Avenue de Tourville at Place Vauban where the French writer and aviator, Antoine De Saint-Exupery, once lived. I continued on down the long, wide street called Lowedal.

I could hear the horns of autos blaring, the autos themselves crisscrossing rapidly across the streets. Slowing my pace, I ran past the UNESCO House and the École Militaire. The flag poles at UNESCO stood like muted soldiers standing on guard mount.

I picked up my pace and stared at the École Militaire barracks with their ancient stucco facades. I began to circle the French military academy towards the Camp-de-Mars. As I was making my way back and was approaching the Eglise du Dôme once again, I sprinted down towards Montparnasse and in the direction of the American Hotel.

I loved running on winter nights in Paris. After seeing the École Militaire in Paris on that evening's run, I began to have hope that one day I would write my own pages of military history and contribute to that genre.

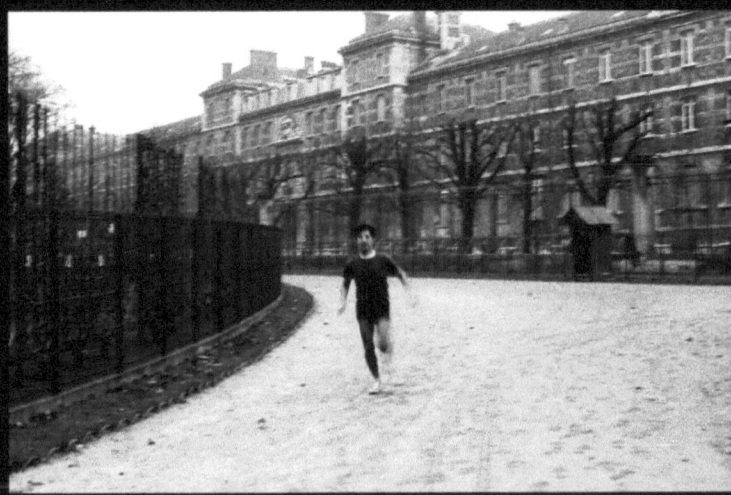

TWO CITIES

SAIDA BADEYAN, I WILL WAIT FOR YOU

Saida, I will wait for you,
Even in these days of darkness,
Where the innocents lay maimed
or dying in the streets
of Bourj al- Barajneh district,
Beirut
There, in Lebanon,
broken glass and broken lives despair.

Here, also, I will wait for you,
In my own tortured country,
As I awaited you through our words,
The terrorism of these days and nights
not extinguishing our love.
Amidst the burnt-out open-air market,
Where the people once walked and laughed
in Beirut, Paris of the Middle East,
Where both beauty and horror thrives
like ancient gods, so brittle in the night,
I will wait for you.
 Luis Lazaro Tijerina

NOVEMBER 13, 2015 IN PARIS

Paris does not ask for glory or tears,
Parisian blood on walls and streets
live-streaming in our lives,
in the pit of our hearts.
Paris will never ask for the last rites in this world,
Paris, where innocents have died on this night,
Paris, the cradle of revolution,
Paris, the city of light and lovers,
Paris,
we pay homage to you on this night of all nights.

Luis Lázaro Tijerina, November 13, 2015

"America is my country and Paris is my hometown."

Gertrude Stein

At the Barricades of Barcelona, Spain 1936-39

Cranston Knight

They stood in silence
perspiration
soaking into
bandannas around their collars
sun rays descending
tiptoeing
on barricades
linking trenches
quickly dug
to resist the galloping hordes
they sung
the Internationale
and íNo Passaran!
as the first blood drops
ran across daybreak radiance
but could not obscure the notes
which rose into the vaulted heavens
of thermals battle wrath
people stood
in an array in of reddish hue
holding contoured
ideological black berets

II
evening tides of darkness closed
on an array of
explosions and tracers flares
ablaze against the night's air
dusk lift the gun powdered
curtain/
dawn
highlighted comrades
 battered
 steadfast
 tearful jubilation

III
dust swirls
as a single fist
 rises
 in Barcelona

 íNo Passaran!

Perfume River
(*Sông Hương* or *Hương Giang*) Hue

Cranston Knight

In the spring
the revolution came from beneath the flowers
flowing into the Perfume River in Hue
The river's fragrance has known
the scent of conflict and tranquility

It is here/ in this place
where a leaf could and can
lay its head/ bullet ridden
and still find rest
your days were spent here preparing

Here
the sun and the moon collided
and overlapped into
a caldron of boiling thunder
you lived in the lines of an inferno
gained life/but at this juncture
you set/ for a moment to reflect
on the beginning of it all/at the perfumed River

ALEPPO
scrapbook memories 1978

ALEPPO DIARY
Dave Donohue

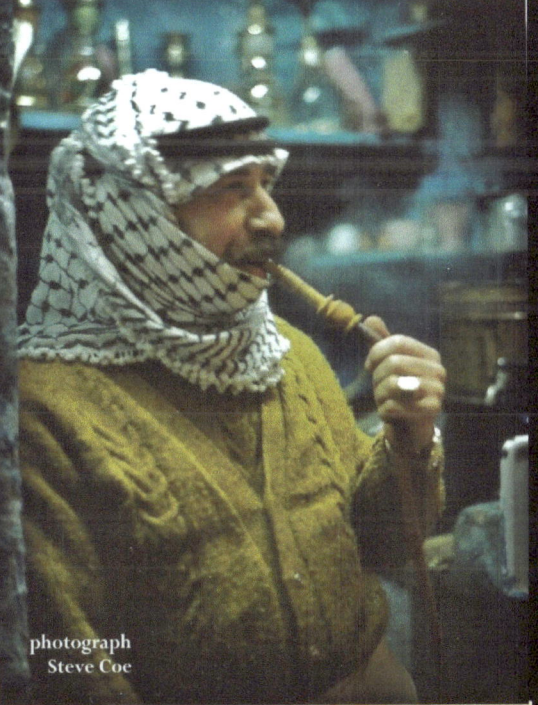

photograph
Steve Coe

January 30, 1978
Left for Aleppo today. Arrived 5:10 PM. Hotel Claridge. Great old hotel with a weird old-world-expatriate-British charm. Good meal.
While at the Syrian border, the guard looked at our three passports. Two British. One American. He looked up at me and stated that Americans are not favored in his country. He then waved us all on through.

January 31, 1978
Walked about the town. Went through the magnificent souk, an area filled with exotic sights and scents. Visited three churches in the afternoon. Christian Maronite. Armenian. Syrian Christian. Strange settings of the Byzantine faith.

February 1, 1978
Took on the citadel today. This imposing structure dominating the center of the city dates back to the time of Tamerlane. An excellent place. A beautiful day. Took photographs of the Omayad Mosque.
Cay houses filled with old men, water pipes, a legless beggar going about business from table to table. A scene as timeless as the city itself.
Dinner at Strand Restaurant - great meal. Aleppo is a vibrant university town but one in which you can also get lost in time walking the streets at night. The atmosphere of the city's Silk Route era lingers.

February 2, 1978
At 10AM went by taxi to St. Simeon Basilica. Lonely beautiful spot in a stark countryside. This was the site where an early Christian holy man spent years atop a pillar in contemplation of the Christ - the basis for Bunuel film *Simon of the Desert*.
Drove through villages of beehive houses.

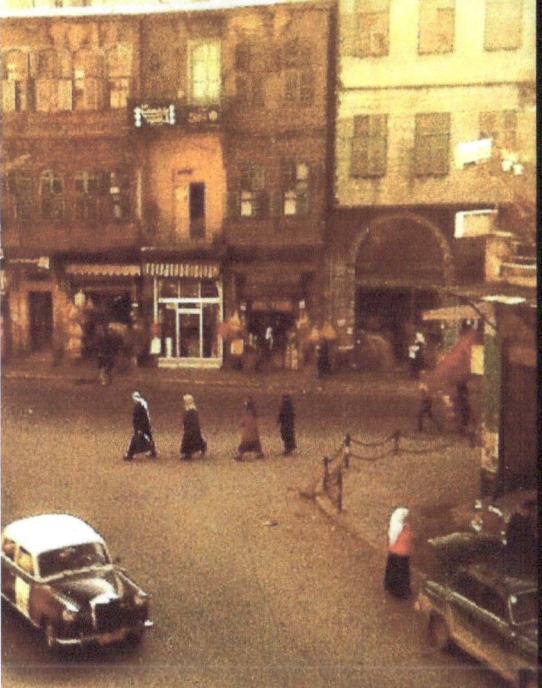

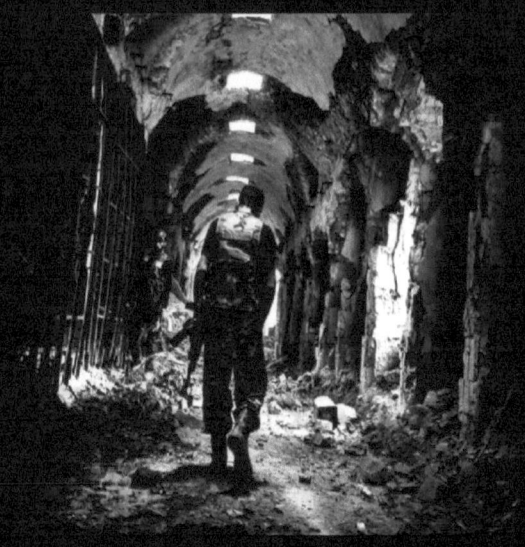

ALEPPO

In Aleppo, I saw carnage left by war
and the shepherds who fled
like others down winding dusty roads
carved from centuries of wind
and the footsteps of soldiers' heels.

———

Here, among the freezes of the Hittites
where myrtle mingles with the dead,
an ancient Syria rises up from its Citadel,
drenched in spume and blood.

Today, the newspapers and television
tell of thousands slaughtered.
Night has spilled its black ink over Syria
but the sun will burn again.
The rug vendors, coffee drinkers, and chess players
will come out into the streets of Damascus,
with their fists raised.
The dry air will celebrate its bleached bones.

 Luis Lázaro Tijerina

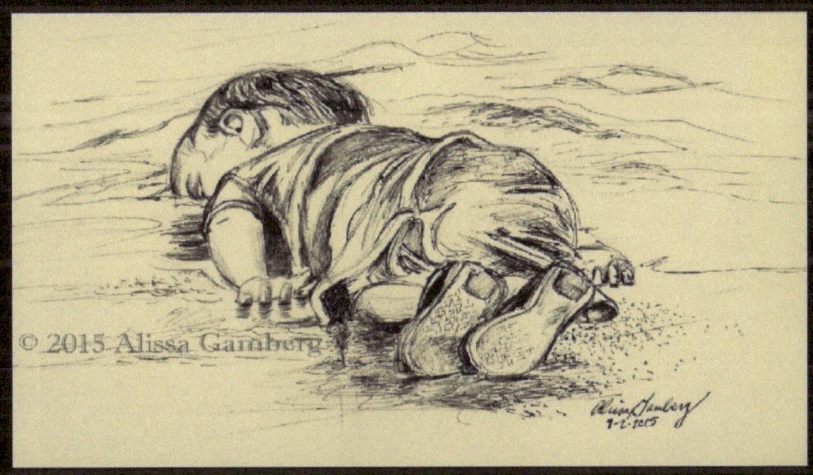

THE DEAD CHILD UPON THE SHORE
 (for Aylan Kurdi)

"We men are wretched things."
— Homer, the Iliad

Dead child upon this shore at Bodrum,
Where did you come from?
Did you flee with your family from Aleppo or Palmyra?
Your body lying face down in death on a wet beach,
Waves coming in from the sea,
Where the dolphins dive and sing,
Where the guts of sunken ships of war lay buried.
Who killed you, child, before you reached this shore?
Bankers, smugglers, or was it politicians?
Was it the Americans, with their lust for oil
in Iraq, that forced your journey?
Was it ISIS, with their demented vision of a Caliphate,
that brought you near this city
known in the ancient world as Halicarnassus?
One of the Seven Wonders of the World
was famous here,
But the image of you lying peacefully upon the shore,
The Mausoleum of Mausolus cannot rival,
And your memory will outlive us.

Luis Lázaro Tijerina

Chanson d'automne

Les sanglots longs
Des violons
De l'automne
Blessent mon coeur
D'une langueur
Monotone.
Tout suffocant
Et blême, quand
Sonne l'heure,
Je me souviens
Des jours anciens
Et je pleure;
Et je m'en vais
Au vent mauvais
Qui m'emporte
Deçà, delà,
Pareil à la
Feuille morte.

Paul Verlaine
translation
Jeremiah T. Duboff

Fall in Song

Autumn violins'
Undone grieving
glissando strokes
Now poke, now choke
This heart's heaving
Engines.
The hours creep
Up, out they ring;
Rememb'ring time
Lost is all I'm;
Wan, breath wanting,
Tears seep.
On musty gusts
Hither, thither
Riding, ridden
I bide. Bidden
Dead, I quiver

UPON REACHING CROWN POINT
Luis Lázaro Tijerina

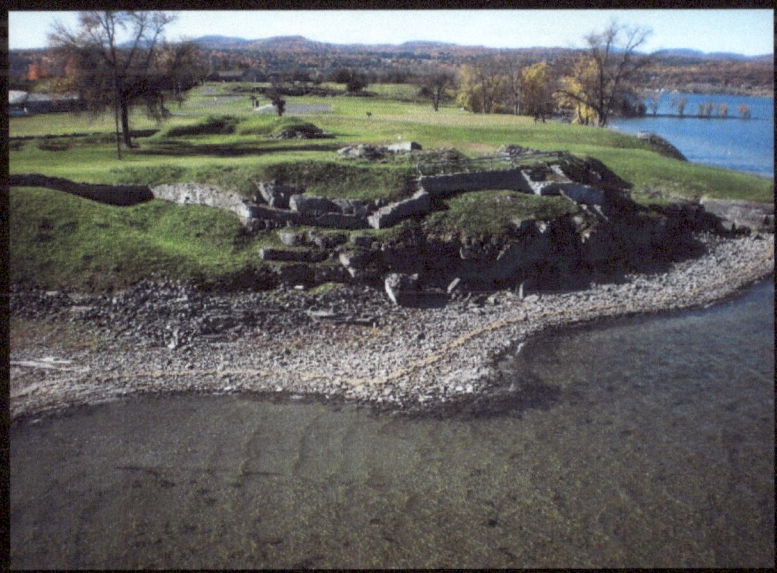

As I stepped upon the Crown Point peninsula, I felt a sudden fear mixed with apprehension - a soldier's resignation; a resignation that I had not felt since my time as a youth in the army. I stood there intensely studying the small limestone remains and outlines of the former structure, scattered along the grassy ground that seemed to be slowly drawing the last of the French fort into the ground. What maze of gray and black limestone that was left looked like an abandoned archaeological site in silent disarray. The sun was beginning to set. The trees now growing among the remains of the forest weaved their way into the almost leaden sky.

I walked among the ruins and looked out to the strip of water that moved serenely between New York and Vermont. As a military historian, I recognized immediately how this destroyed fort was once vital to the welfare of New France. Originally named Fort Beauharnois, it was later the official Fort Saint-Frédéric, after Jean-Frederic Phélypeau, Comte de Maurepas, the chief minister of France in 1736. From this peninsula there was a strategic, geographical point from which one could control all north-south water travel in the Champlain Valley region. But it was more than a military domain to be reckoned with -- the fort was also a major economic location that either the French or British North American empires could benefit from in their expansionist and hegemony policies.

When a serious visitor looks at the remains of this poetic limestone rubble, the outline of a once powerful military bastion that thrived during the Seven Years War becomes clear. Commerce, and not culture, played a deadly move to control the vital gateways to Canada and down the waterways of Lake Champlain that ended south into British colonial territory.

CAMILLE CLAUDEL FACES NORTH

Sadly, Camille faces north
 not with hope or whimsy
but with despair black
as the tumult within her
the darkness that led
to her confinement in Montforet,
her thirty years of desolate isolation.

A student of such promise
 with Boucher, then Rodin
 - the latter - her mentor, her lover,
 his inspiration.

In marble, in bronze
Camille's works, exquisite, some survived,
though many destroyed by her madness.

Sadly, Camille faces north
 above the waters of Champlain
more than a century of so doing
lonely, forgotten again
looking north, towards New France
 towards someone to unearth a genius
buried so long ago
 in Montforet's communal grave.

Dave Donohue

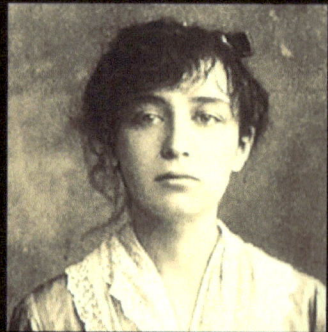

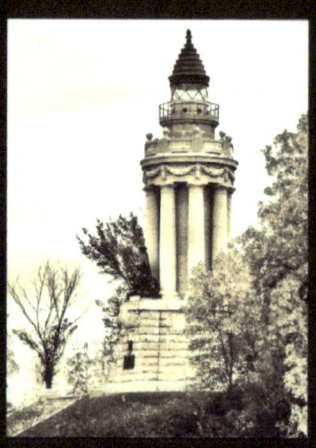

Crown Point, New York

A Café

Christopher Ricker

The rain began to pour only after we had entered the establishment. Patrons entering after us looked like wet sheep. In fact, their woolen coats smelled damp and, had it not been for the aroma of spices and savory sauces from somewhere off in the kitchen, their damp smell would have been overbearing.

Marie sat across from me at our table located near the front window. When the waiter came we ordered red wine and starters.

Our window was framed in stained glass, matching the blown glass shades of the overhead hanging lamps.

I found myself looking out this window periodically. Montreal huddled outside, a loud and lonely hunchback. I meditated on the fleeting nature of it all. That nothing ever lasts. That everything in this transitory world will extinguish itself one day.

Black umbrellas passed under the Market Street lights. Some moved in pairs, while others tread on alone.

Marie smiled. I smiled back.

At times, we spoke of amusing nonsense while, at other moments, the conversation became serious. When we had finished the hors d'oeuvre, the waiter returned to ask us what entrées we'd like.

"I'll have the white fish on a salad," said Marie.

"And for Monsieur?"

"The lamb stew with a side of sweet potatoes."

"Très bien! And more wine?"

"Yes, please."

Between the glasses of wine I could feel stares emanating from others in the room. It might have been my paranoia, to be sure, but I believe paranoia comes from some basic instinct.

Everyone in the room knew me and understood Marie. I had been in this place before in a past life and often a crowd does not allow the ghosts to sleep.

The food came, its aroma inviting.

Marie ate her white fish on salad. A little lemon juice and Italian herb stuck to her lower lip. When she realized it she smiled and dabbed it away with her napkin.

The lamb stew was hot and warming and I knew that, between the stew and the wine, the awaiting rain, the awaiting world itself, would not harm us. Good food and good wine are essentials to well-being.

I had not been back to Montreal for some time. Whenever I returned I was always overcome with guilt for never having visited Europe when I had had the chance. Lisbon and Paris seemed always to have escaped me.

I had settled for Montreal as my cosmopolitan alternative long ago.

I hoped that the next morning we could visit the Butterfly Museum, have espressos in cafes in the old town, and wander the farmer's market. These were all mere hopes as no one really knew what tomorrow would bring.

There was a rose in a wine bottle vase in the center of the table. "Some people are always grumbling because roses have thorns. I am thankful that thorns have roses," I said.

"Who wrote that? Was it you?" she asked.

"Yes! No, I am lying. I was thinking of you the other night, late, when I came across that quote. I wanted to share it with you then, call you up, except it didn't seem an appropriate time."

Marie thought a moment. She smiled coyly. "Yours is a much more compassionate viewpoint - much more so than accusing roses of having thorns for spite!"

YES

Kate Mohanty

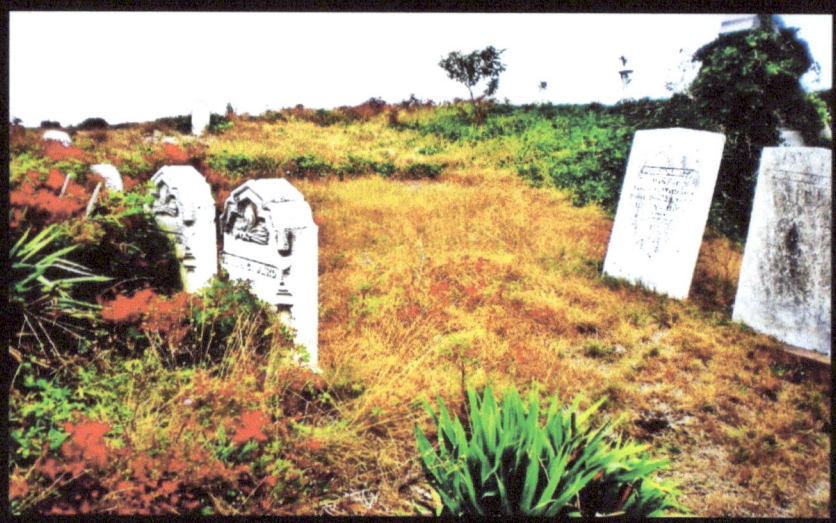

Provincetown Cemetery

Advertisement

Painting gravestones, the art
Of the future

Let 'em shine in the moonlight, boy
Let 'em worship like little soldiers
Swell past like little strangers
Under a violet sky

Paint 'em green, boy
Paint 'em green and gold
Make 'em look
Like the grass and the stars

Charles Watts

A friend's daughter died today

The flow of blood through the brain
Like a trough full of grain
Was eaten up.

She was nine.

A hollow egg
Full of her mother's eyes.

The corpse of a child
Should never be viewed.

Like a miner buried alive
The black grave saves
Through the sanity of ignorance.

Rest child,
You are not needed now.

Break the heart of God
When you find him.

Let the prick know
What he's done.

 Shane Rooney

Tree at ruins
 of Malinalco, Mexico
Sergio Ricardo Melesio Nolasco

Flower
Sergio Ricardo Melesio Nolasco

Elena Koltsova
Moon Month and Red Crocodile
Krasnoyarsk, Russia.

Elena Koltsova
Cricket Violin Recital
Krasnoyarsk, Russia.

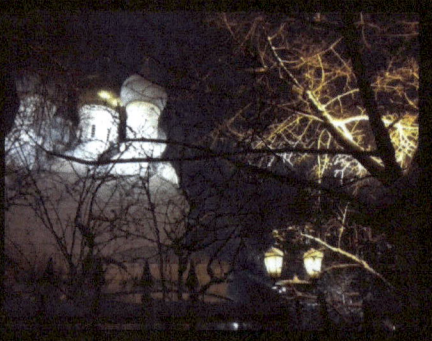

Maria Muraveva
Church of St. Nicholas in Pyzhi in Moscow

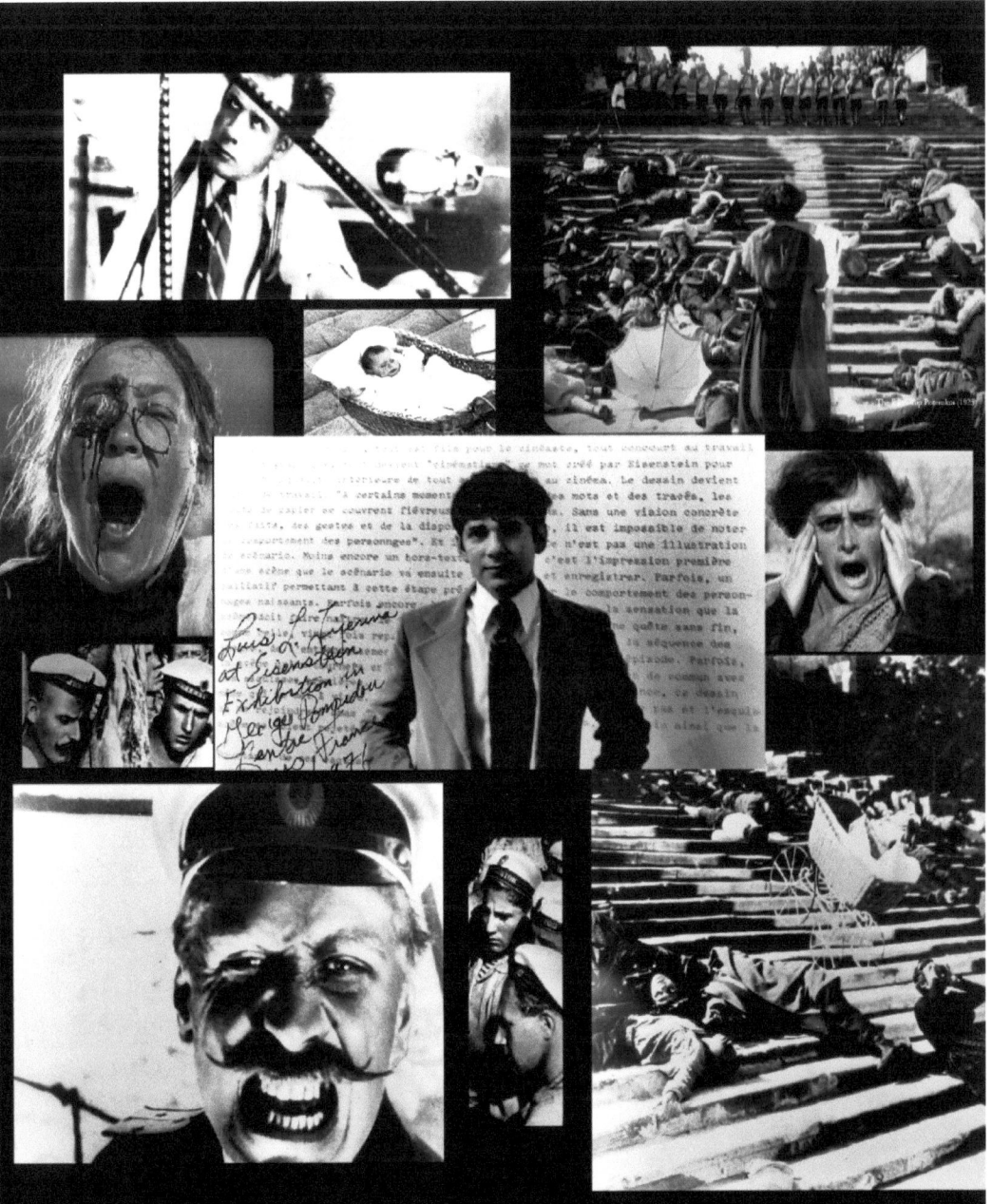

"Language is much closer to film than painting is."
Sergei Eisenstein

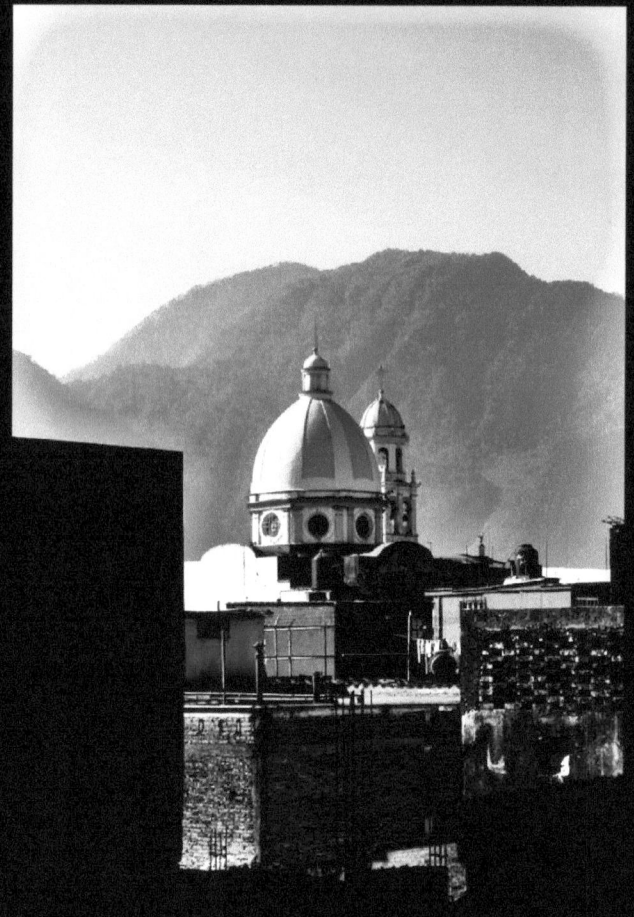

Bell Tower and the Mountain, Orizaba, Mexico

Sergio Ricardo Melesio Nolasco

ALISSA GAMBERG'S SAN SEBASTIAN

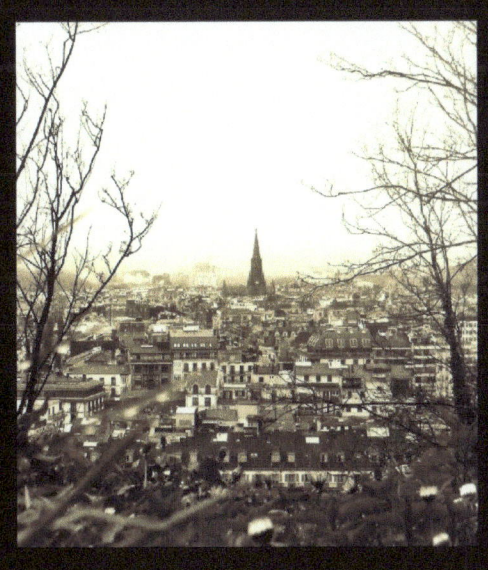

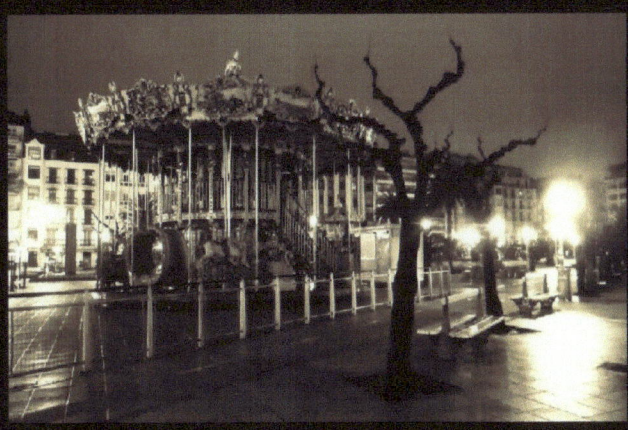

Boy
jodhi reis

Boy did white lies seep through
Temptations sneak fools
Habit fed and swallowed
Our dead and borrowed
Misconceptions of space, time
Rhymes you never mettle with syntax.

They are not to blame
Waned generations
Pass on
Fault lines
Autonomous crimes
Grind glitch to name
Profane and true

You are the only one
To play
Instruments:
Man
Boy
Etched purpose or
Tool

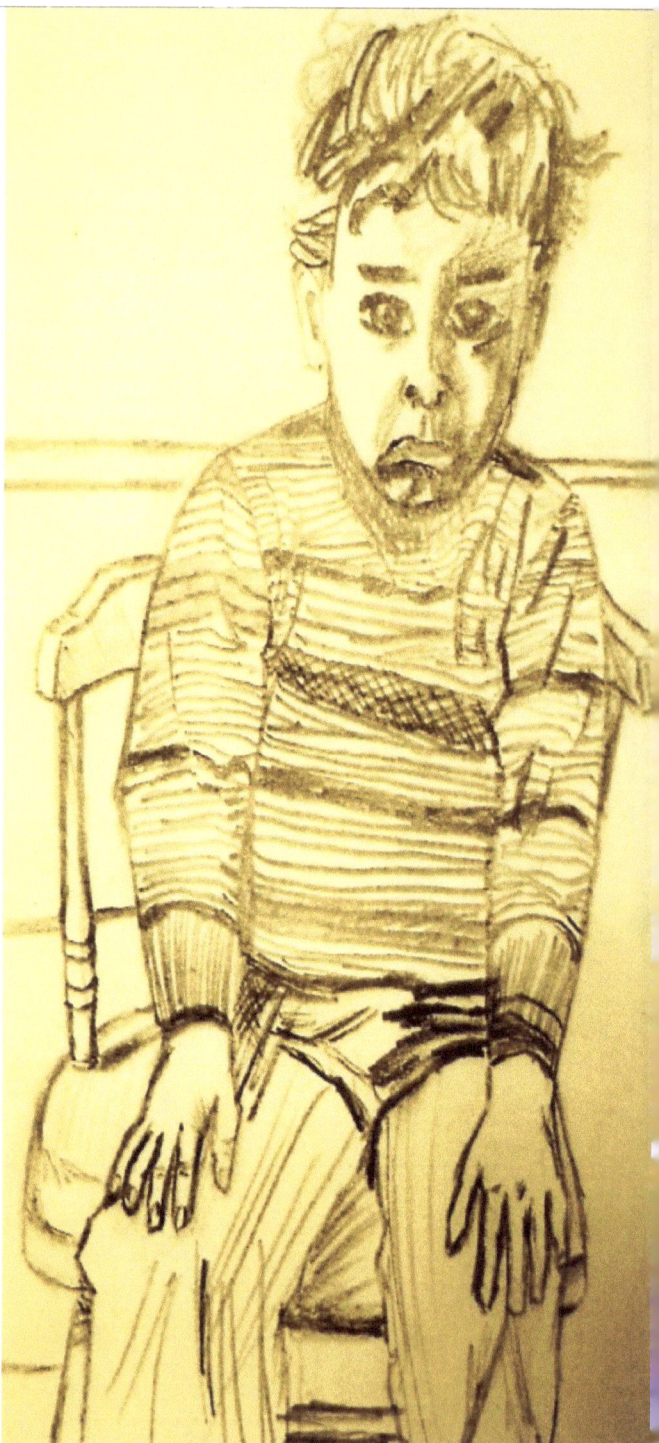

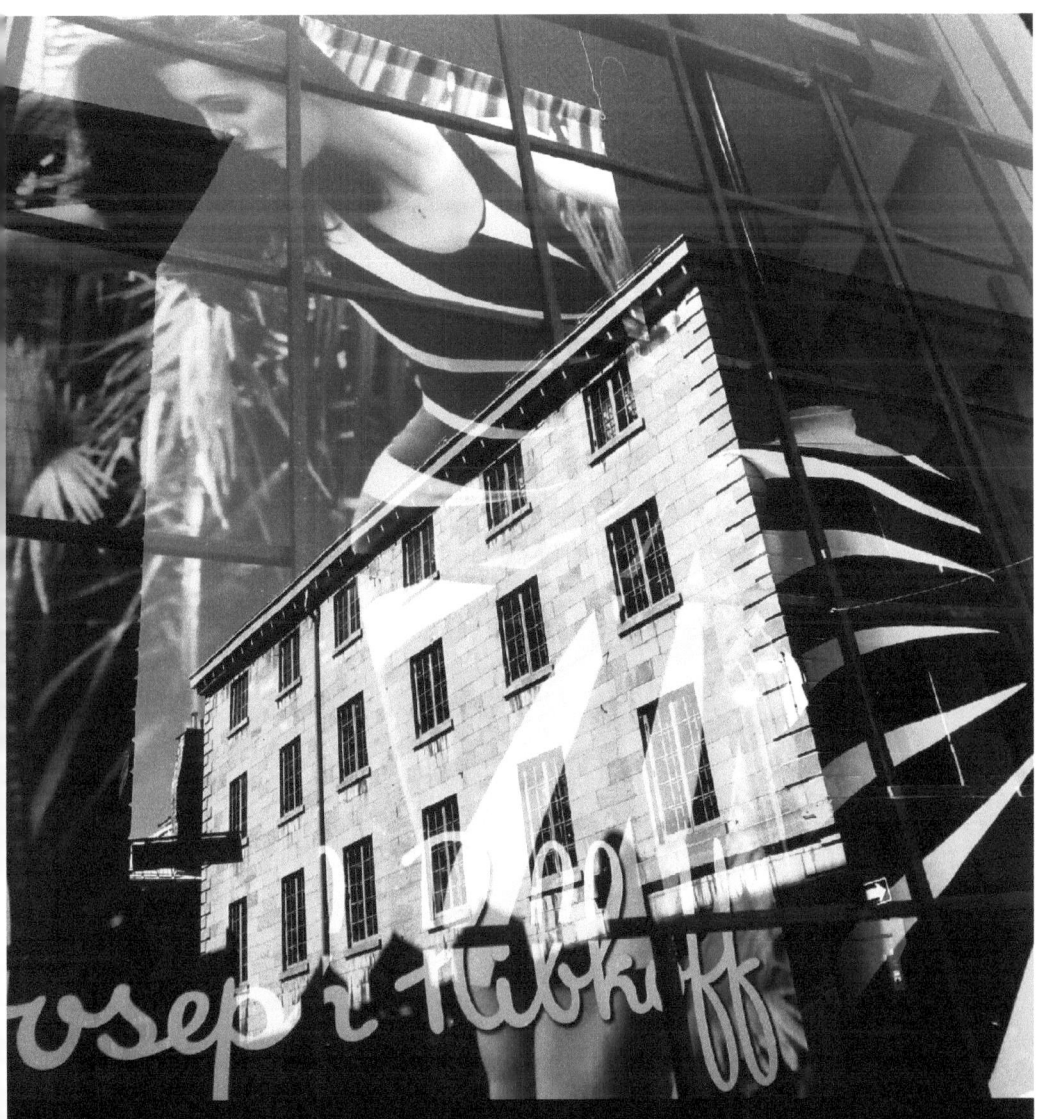

Luis Lázaro Tijerina

"Surrealism is destructive, but it destroys only what it considers to be shackles limiting our vision."

Salvador Dali

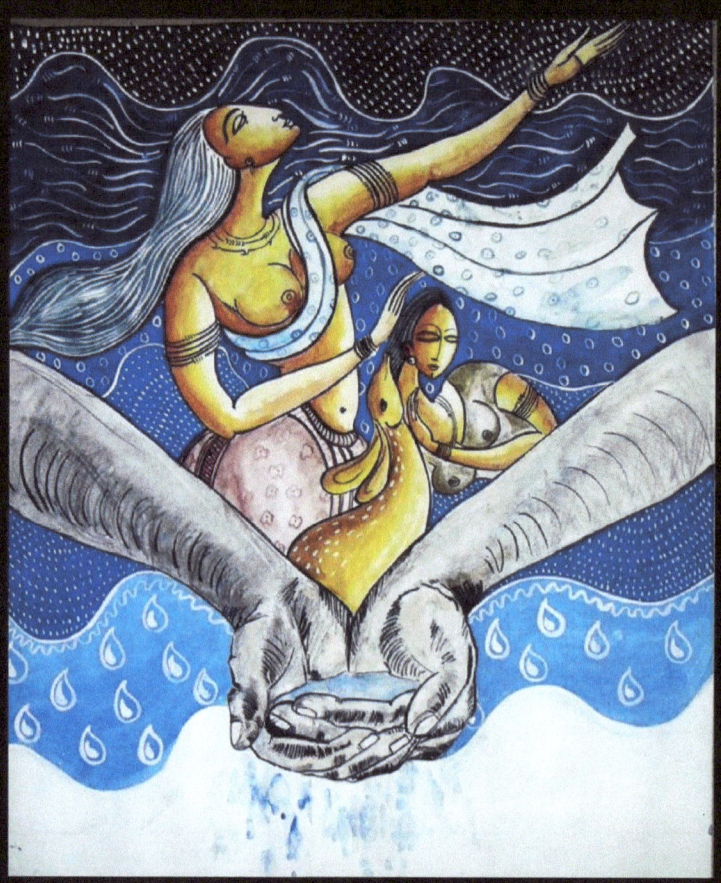

SAVE WATER

Sewwandi Daladawattha

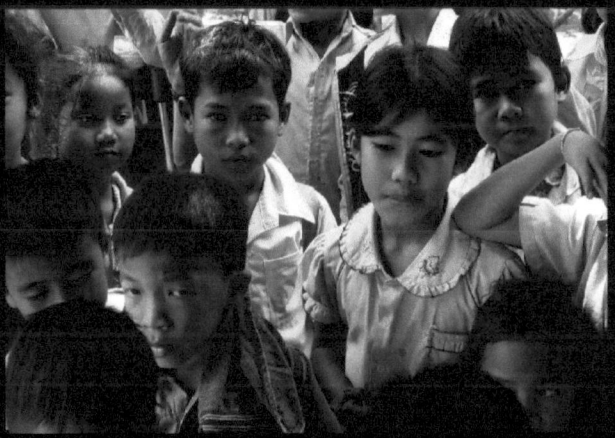

photograph by Pat Farren

I, TOO, WOULD LIKE YOU

I, too, would like you
to wear a torn dress
to eat food from the dustbin
to drink water from the drain
to sleep on the pavement
 on cardboard with a dog
to experience that feeling before I die
 by giving you my bed.

 Sehan Kavinda, Sri Lanka

TWO POEMS

Alexander Gabbrielli

PEDALS

Pedals by which souls maneuver moving machines,
Souls become reduced to this:
Deda dada the constant rattling of the motors
The shaking of our marrow...

SELF PORTRAIT

A self-portrait
Is actually interesting in natural color,
The flesh (actually the skin) is still barely visible
But it still glows
I do believe in ambers that cannot go out.
Call it life
Death

Cat on a Bridge
Sergio Ricardo Melesio Nolasco

THE DOMINIC SAVIO CLUB

Dave Donohue

The perfect saint for the 1950's
was young Dominic Savio

An example to all young boys
someone to follow, someone to emulate

Canonized by Pius XII in '54
Dominic was fresh and new to the saintly
 ranks

And so clubs were formed
In grades 5 and 6 for the boys' classes

The students were given badges
holy cards and other paraphernalia
 of the teenage saint

Meetings were called
and motions were made about living in
 Dominic's state of grace

And the church looked upon this
as a very very good thing

For Dominic lived a perfect
life in the Catholic way

An altar boy at five, a seminarian at twelve
and a corpse at fifteen

Dead before the natural way of the flesh could wage
war with his inner self.

"What beautiful things I see!"
his last words.

A perfect example of purity
remaining uncorrupted.

Of a spirit
finding no impediment from the flesh

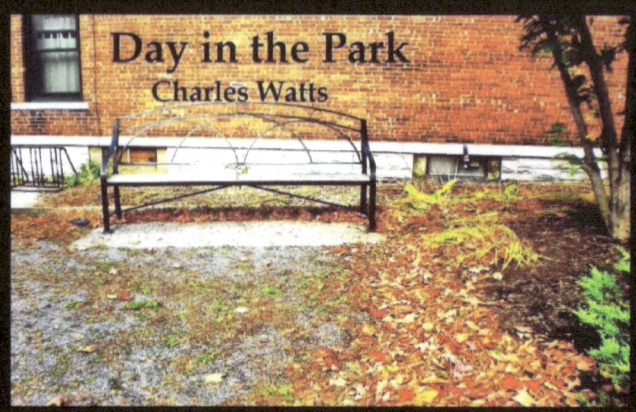

Day in the Park
Charles Watts

Middlebury, Vermont

crouched between the pines
watching a hole that could belong to snakes
discovering rusted waterpipes
in this apparently abandoned
stand of weeds
piling dirt on the wings of bees
is unnaturally hard

counting a band of ants to their feast
swollen with red grains
and sweet fallen honey
plump maggots hoisting their white, smooth bodies
into the bodies of dead sparrows
graceless grandmother nature stoops
lifts the earth like a carpet
and sweeps our dust under
can you feel the lumps in your back

pythons asphyxiate themselves
on the heads of water buffalo
poison butterflies kill the frogs
that eat them
leave notes for their eggs to read
a poet takes his dutiful pictures
and enters them in a contest

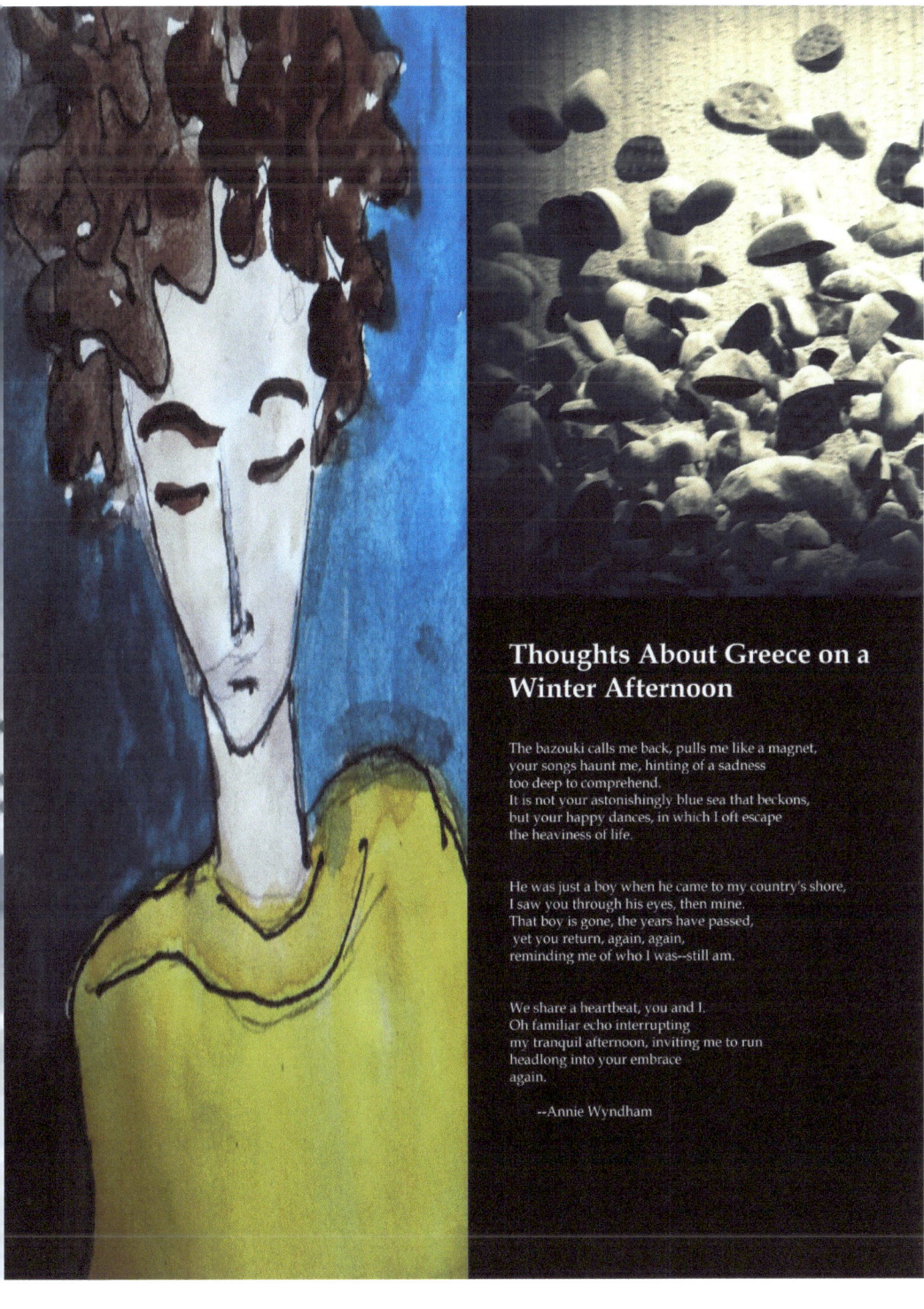

Thoughts About Greece on a Winter Afternoon

The bazouki calls me back, pulls me like a magnet,
your songs haunt me, hinting of a sadness
too deep to comprehend.
It is not your astonishingly blue sea that beckons,
but your happy dances, in which I oft escape
the heaviness of life.

He was just a boy when he came to my country's shore,
I saw you through his eyes, then mine.
That boy is gone, the years have passed,
yet you return, again, again,
reminding me of who I was--still am.

We share a heartbeat, you and I.
Oh familiar echo interrupting
my tranquil afternoon, inviting me to run
headlong into your embrace
again.

 --Annie Wyndham

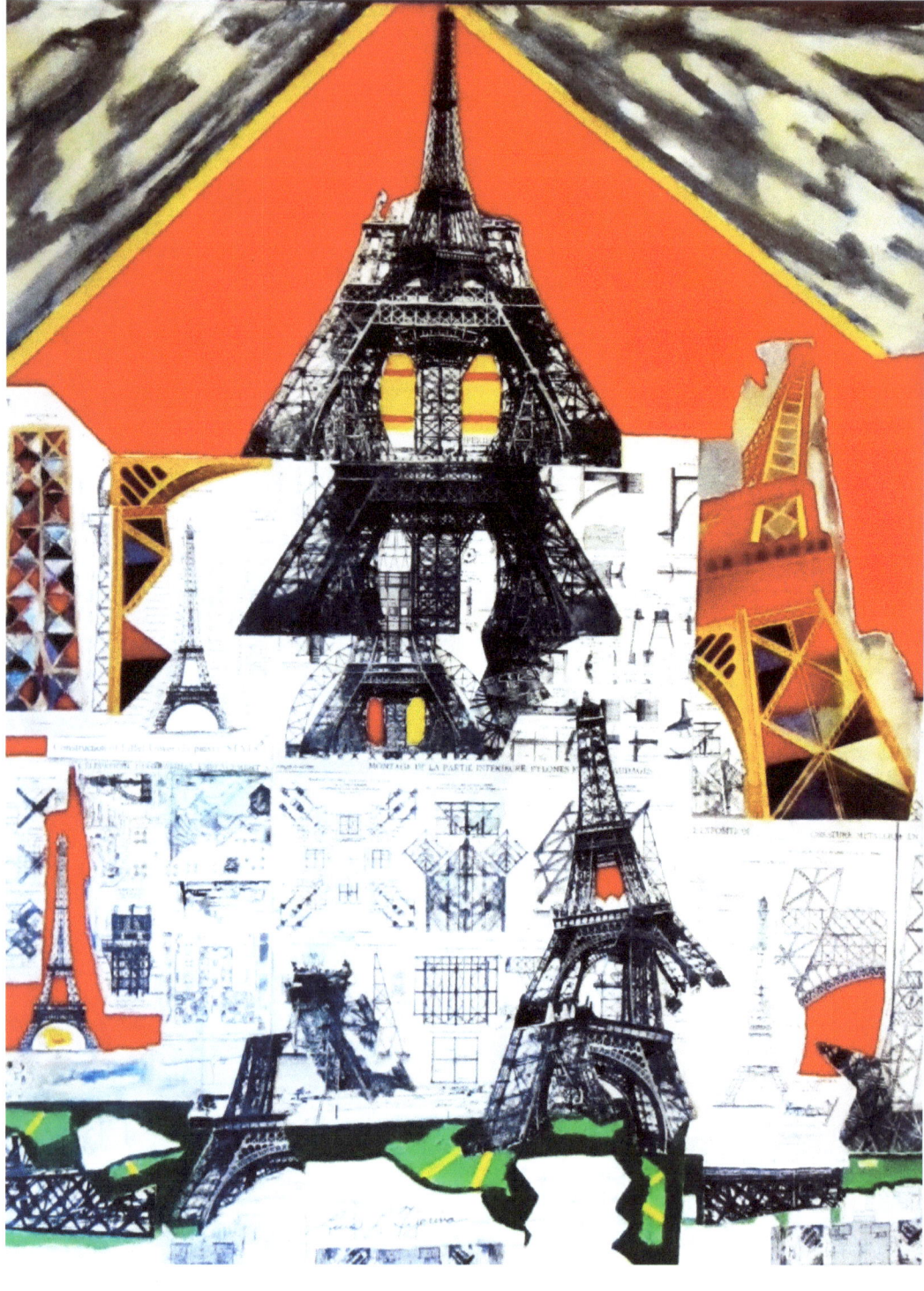

excerpts from
MEMOIR OF PARIS

Luis Lázaro Tijerina

I would write what I thought was my first serious prose in Paris. I was a dreamer then, thinking that simply reading Neruda's poetry would solve the world's problems. I was a naïve young man in Paris. My son, Eli, had not yet been born. I knew nothing about manhood or responsibility. What I brought with me to Paris was simple: a passion for life and art. I later wrote my feelings about the moments in my journal when Judith and I walked across the Pont Neuf towards the Louvre, where we would see the great art of the Western world:

A gentle, wispy rain is falling across Paris… The streets are wet and slick. An air of silence, of lovely and absolute silence hovers over Paris, this city of French workers, literary conquerors, street hustlers, broken and energetic artists, the European poor and the lonely misfits. I hear trucks and autos moving through the streets where De Gaulle, Victor Hugo, and Ehrenburg must have walked.

Judith and I had found a hotel room right in the center of *La Defense*. I hated *La Defense*, the up-and-coming 'modern' Paris of the day, one of smooth, airless skyscrapers that reminded me of American warehouses. Tiled plazas were squared in neatly between apartment buildings, hotels, and ultra-modern street lamps. When my wife and I stood staring through the thin glass windows of the hotel, we saw the other Paris in the distance, the Paris of dingy, gray smoke rising from furnaces and double-barreled chimney stacks. We knew where we wanted to go. We left for the Left Bank as fast as our legs would take us to the subway.

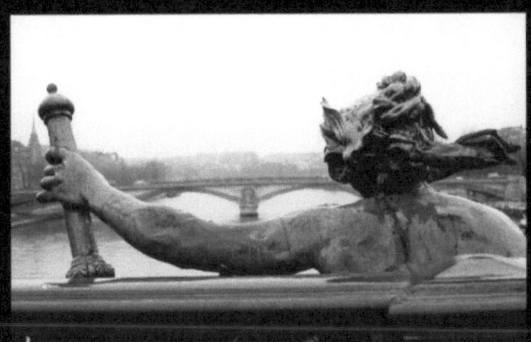

Go Comfort

Go comfort
Once for all go
 Thorn the temple
Of another
 Wretched pillow
I will lock you in
An abandoned icebox
 Cursed couch
I will fracture you
In the coal bin

Go comfort
Who ladles me
With meatball stupor
 Who threads the eyes
Of the world together
 Who staggers
Through the gate
Like a child
To greet me

Come adversity
Enter like a virus
 Wither my arms
Send me
Like a Mandarin duck
 To the platter
Adorned with knives
And hatpins

I am too easy
Now with life
 I am waiting
 For the guillotine repairman
 I am waiting
 For the electricity
To evaporate

Come adversity
 Roll me in flour
 Bake me into French bread
Cut holy symbols
In my brittle crust

poem by Charles Watts
photograph by Pat Farren

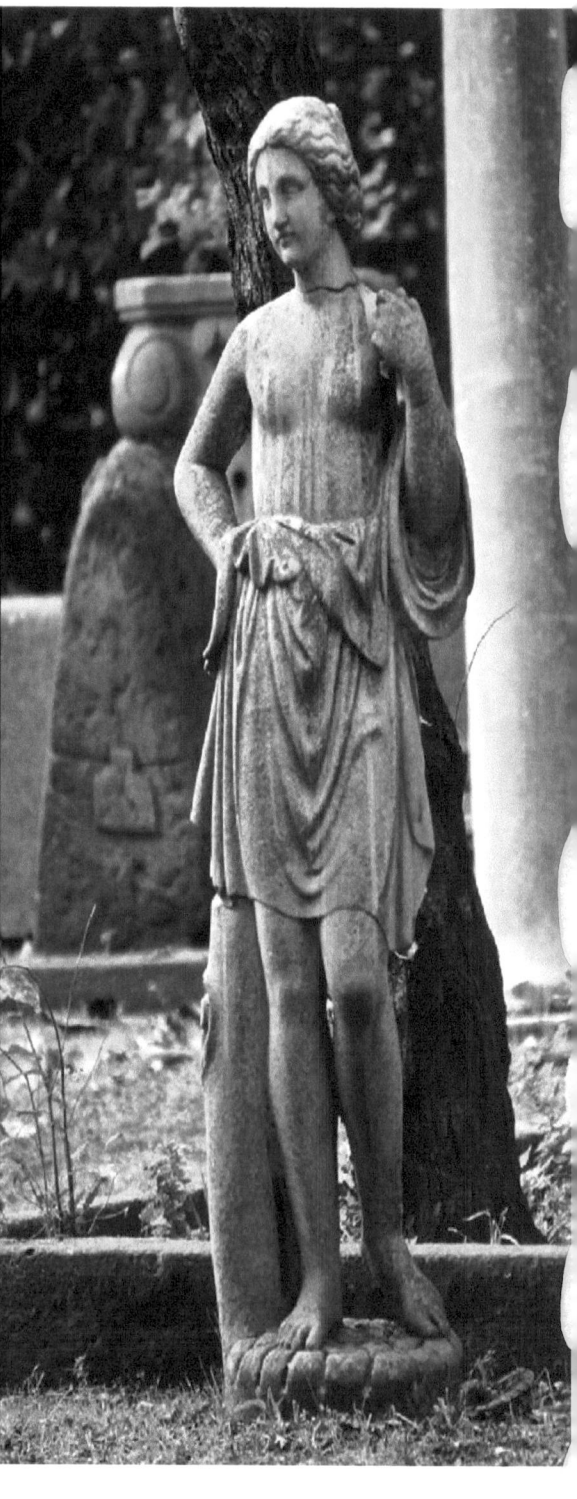

www.ingramcontent.com/pod-product-compliance
Lightning Source LLC
Chambersburg PA
CBHW041116180526
45172CB00001B/271